A People Called Palestine

J.C.Tordai & Graham Usher

Dewi Lewis Publishing

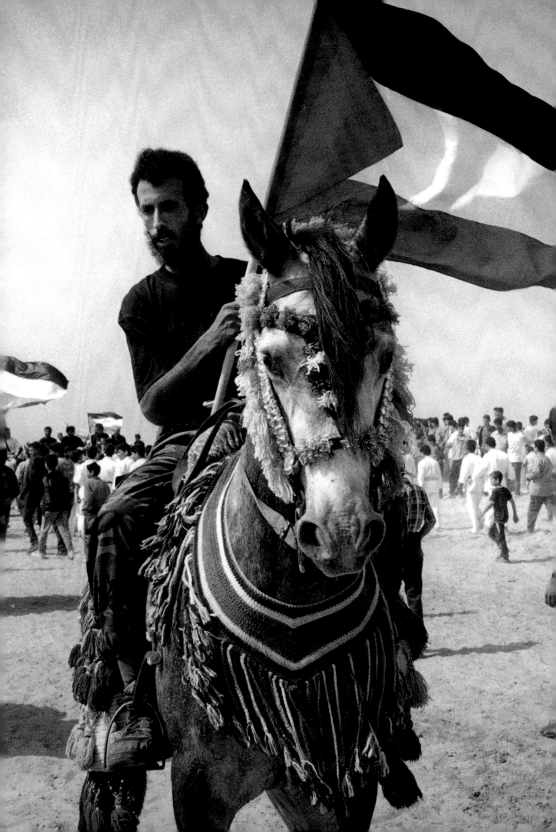

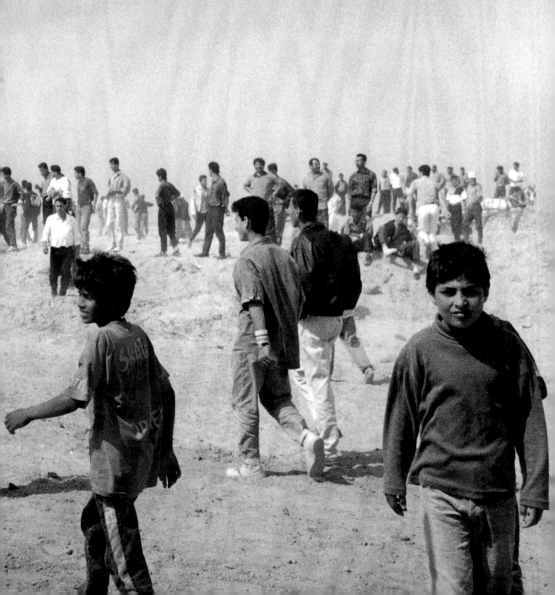

Bearing Witness

There is nothing so instant as an image. The photographer – sunburnt, burdened by cameras – presses through the bustle of Jerusalem's Old City. He pauses before a porch, frames a boy and his mother before a blazing brazier, smiles and trudges on. Another moment captured, filed away, forgotten and onto the next.

Why that moment and not the myriad others stretching out before and behind him? It is of course to do with light, shade and the aesthetics of composition. But in the work of J.C.Tordai it is also to do with the narrative he carries in his head and feels compelled to record, a political as much as an artistic epiphany whose sense is grasped best by the moral, historical need to bear witness. Gathered in this volume is the iconography of a people called Palestine. Looked at correctly each image – whatever its moment – reveals that narrative and poses their question.

Tordai has been photographing Palestinians (and Israelis) for close on twenty years. He was in Gaza in the early 1980s, before it became the fashionable haunt of journalists and TV crews. He returned during the exhilarating early years of the first Palestinian intifada – when all seemed possible – and stuck around as the uprising sank into an attrition of Israeli siege, Palestinian violence and political stalemate.

He was in place to watch the entrée of the 'peace process', as embodied by the return of Yassir Arafat and the remnants of the Palestine Liberation Army to Gaza in 1994 and the slow, deformed birth of the Palestinian Authority. And he was there again when, in September 2000, that artifice finally collapsed amid the blood, arms and death of the intifada el-Aqsa, the second Palestinian national revolt in less than a decade.

The earlier era is collected in Tordai's book, *Into the Promised Land* (Cornerhouse 1991). The stress here is on the period after the 1993 Oslo accords. But it would be wrong to view his narrative as linear, with history merely a canvas endlessly stitched onto the present. Tordai works rather as an archaeologist, sifting away at the surface of things the better to see the ruins that preceded them.

Look, for instance, at the jubilation at Gaza's Rafah crossing that greeted the returning soldiers of 'Arafat's army'. Look more closely and you will see it is an army in defeat, allowed entry on sufferance and under orders to keep the natives in check. Read that in the gaze of the boy at his veteran, uniformed brothers from behind the steel bar fence.

Ambivalence was the temper of those days. It is reflected in the taut, smoke-wreathed faces of three young men from Arafat's Fatah Hawks militia, a shot taken in a safe house in Rafah in 1994. For the previous seven years young men like these had been the legions of the uprising and on the run from the Israelis.

Within months they were to become the staff of the Authority's intelligence forces, with a remit of bringing to heel Gaza's rebellious Islamist movements, represented here in full regalia of mask, machine gun and fire. Within seven years again, they were to turn their guns on an older enemy, masks again wrapped round their faces and the blood of martyrs on their hands as they fought and died for the national, religious cause that is Jerusalem.

The context for the defeat and the resistance was Israel's occupation. By 1994 this had taken the form in Gaza of a sophisticated regimen based on military might, national oppression and economic dependency. Tordai dissects how the system works. The shots he takes of the morning shift crossing the Erez checkpoint into Israel is a reminder of how – through the occupation – the occupier had transformed Gaza from an agrarian society into a sub-proletariat on side to do the jobs Jews in Israel refused to do. The fact that Erez at dawn looks like an earthly Hades should not distract a jot that this is an entirely built mechanism, an entirely man-made hell.

Where pacification failed, violence took its place. Tordai has his fill of 'clash' images, like that of the Israeli soldier in determined pursuit, or of

Palestinians united in rescue. But he does not linger on them. He is interested more in the human aftermath, after the soldiers (and the press) have gone home. Like the keening of a woman on hearing that her son has been shot dead. Or the game of basketball played each week by crippled intifada veterans. Or the sight of a father cradling his disabled son before the wreckage of his home – demolished by the army for want of a licence.

The same eye strips away more layers to expose the raw root of the Palestinian tragedy – that of a society torn apart by the birth of Israel and of a people which, overnight, became without a land. But his angle on the refugees is again not the usual one of pity and/or defiance. He focuses instead on the humdrum ritual of them queuing for flour at an UNRWA distribution centre, and the memory that this stirs of another, better past – another, better country. Tordai goes in search of this past and finds it in the country. Among the women reaping corn beneath the date palms of Deir Balah. In the man digging potatoes with his son in a crate in tow.

He also finds its rupture in a barber's shop in Gaza. Thrust suddenly into the frame is the photograph of Mahmoud al-Aswad, a nationalist fighter killed by the Israelis in 1972. The peasants have become revolutionaries, it proclaims. But what is to become of the revolution if the peasants will never again till their lands? What will become of the nine-year old boy, bandanna around his brow and a loaded pistol in his hand?

You would have to be numb not to feel where Tordai's identification lay. The few images here of the 'other side' deliberately strike discord. Look at the picture of the woman painting a mural of the Palestinian village of Beit Jala from the Jewish settlement of Gilo, built on its land. She is sketching on concrete blocks installed to shield machine gun fire from that village. That night Israeli tanks will fire on the real model of her portraiture. Look at the baseball-capped boy waving an Israeli flag in Newe Deqalim, and remember this is a Jewish settlement of 2,000 people surrounded by Palestinian camps hosting 750,000 refugees.

If these pictures cause dissonance, it is not just because Tordai views them through the lens of a Palestinian. It is because the settlers are dissonance, a community out of place.

As, in a way, is Israel. The shot of the blind soldier finding his way down Jerusalem's Jaffa Road was taken in 1998, the year of Israel's 50th anniversary. It sums up a nation exhausted by war, seeking peace but with no clue where or how to find it.

Tordai's judgements about the Palestinians are more subliminal, seeking subterfuge in a quasi-religious imagery. He shoots the sea. In Gaza, the ocean is the only border that is not closed, free from checkpoints and soldiers and humiliation. The fisherman casting his net and the young girl spreading her arms are both gestures of wonder that the horizon can be so vast when their lives are so imprisoned.

He also has a thing about horses, as do most Arabs. It was on a horse that Mohammed ascended to heaven, on a horse that Salah al-Din rode into Jerusalem, having vanquished the invaders. There are three horses in these pages. Read them as an Arab or Israeli would – from right to left – and the horse rests in a cemetery, climbs to its feet beside the sea and finally, garlanded in triumph, hoists the fighter and the Palestinian flag. Read them the European way and the order is reversed. You make your own order.

But however you read these images, save and protect them. I was there. And I know the shadows cast by each epiphany described.

Graham Usher, January 2001

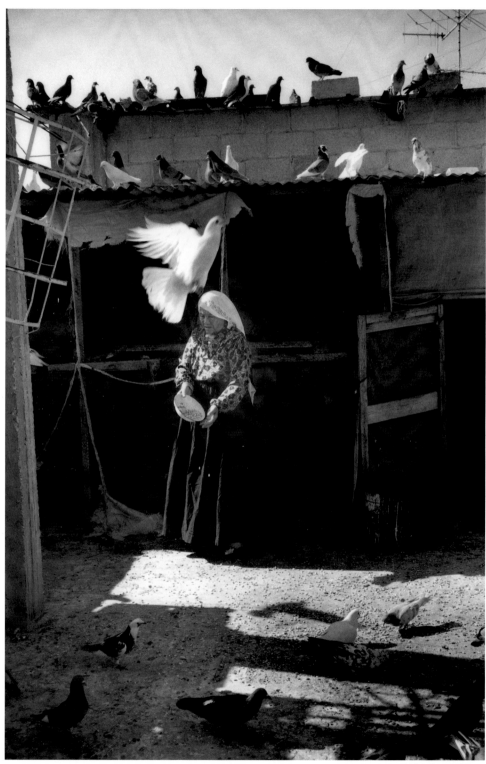

Tel Sultan, 1993

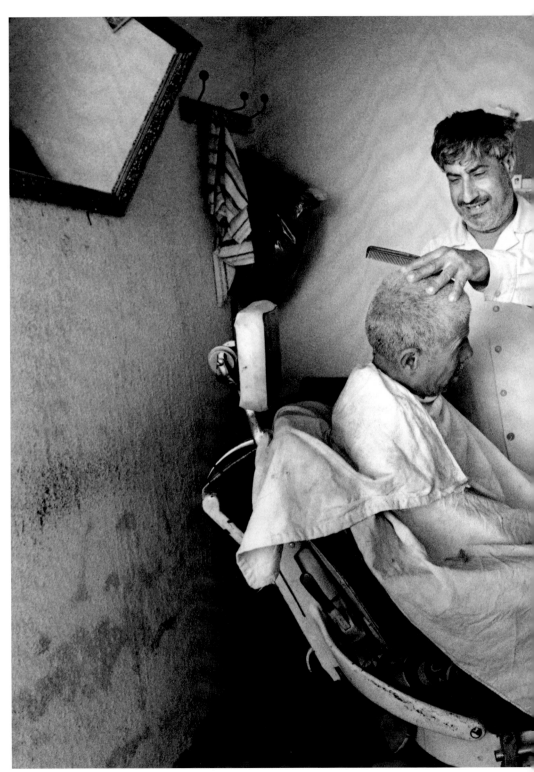

Gaza City, 1993

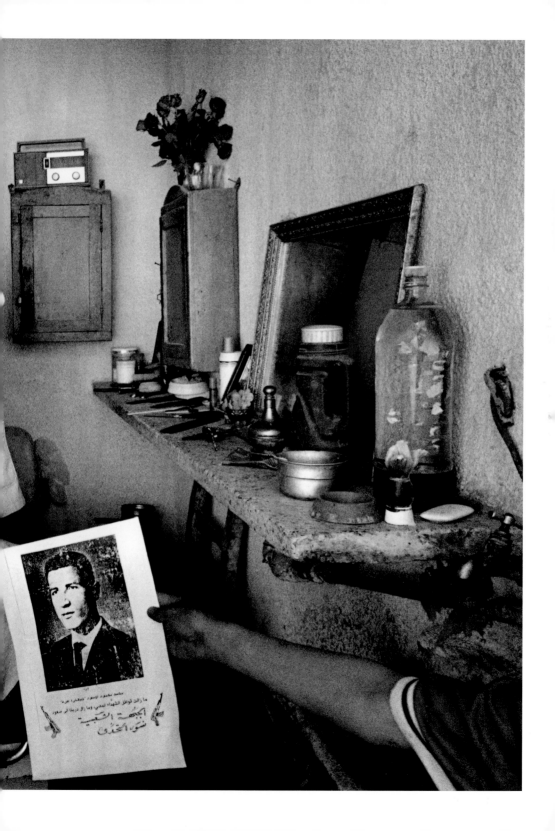

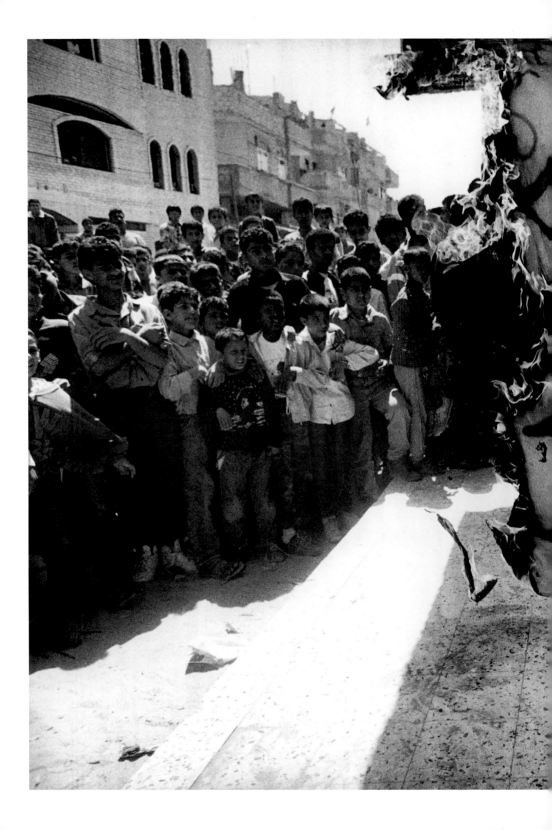

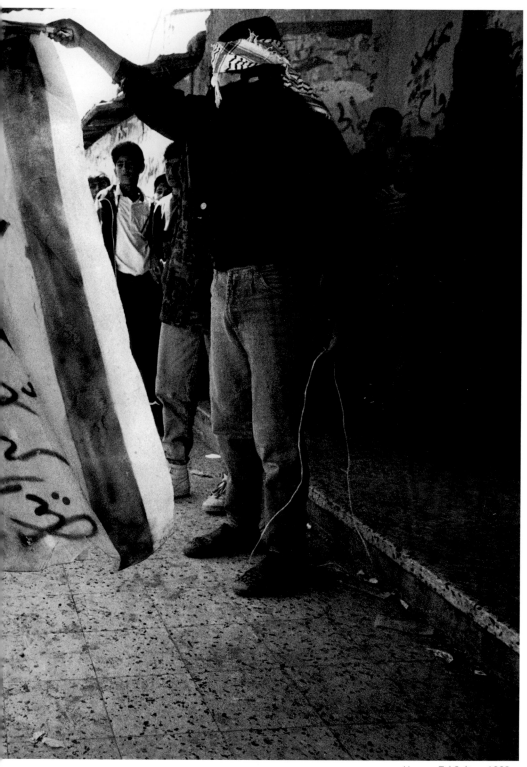

Hamas, Tel Sultan, 1993

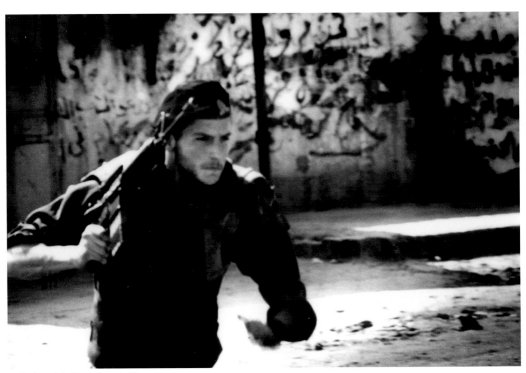

Clashes, Jabalya Camp, 1994

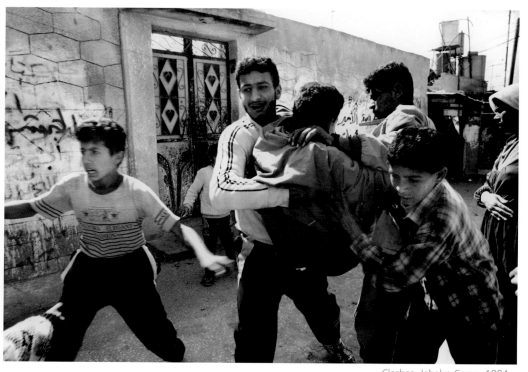

Clashes, Jabalya Camp, 1994

Jabalya, 1993

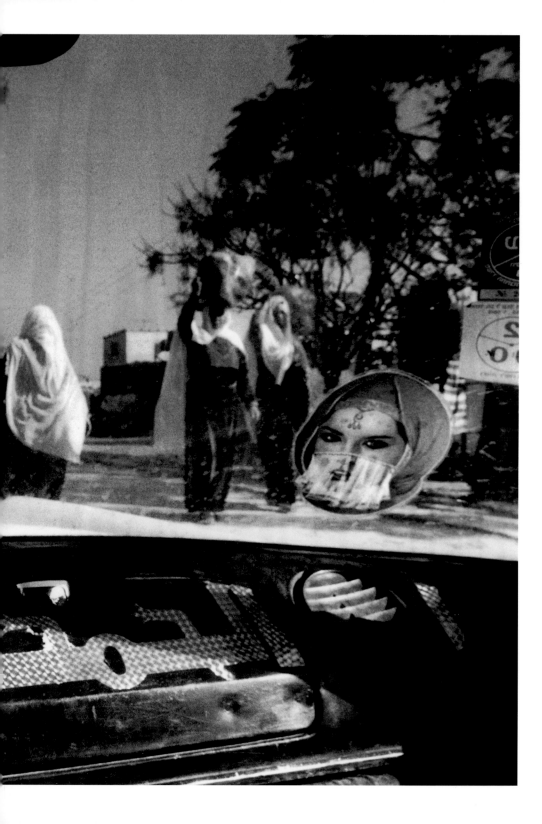

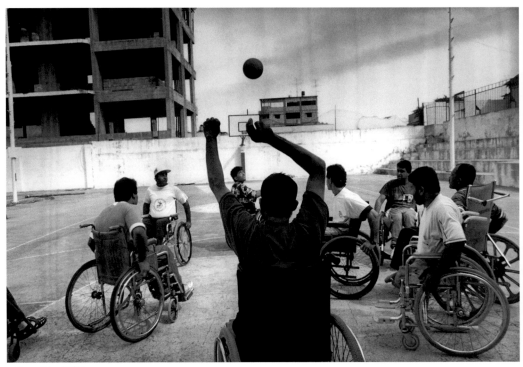

Gaza City, 1994

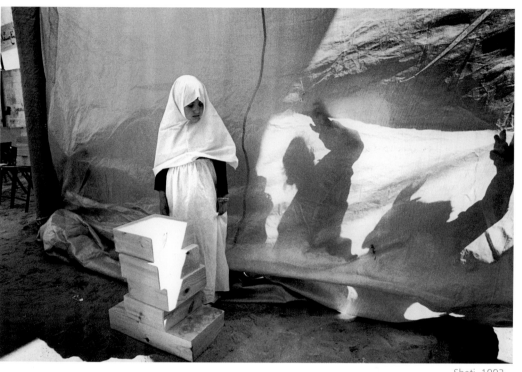

Shati, 1993

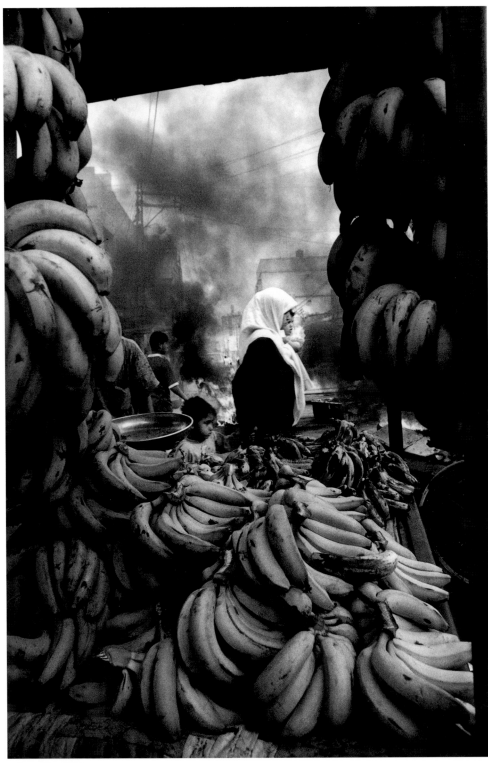

Gaza City, 1993

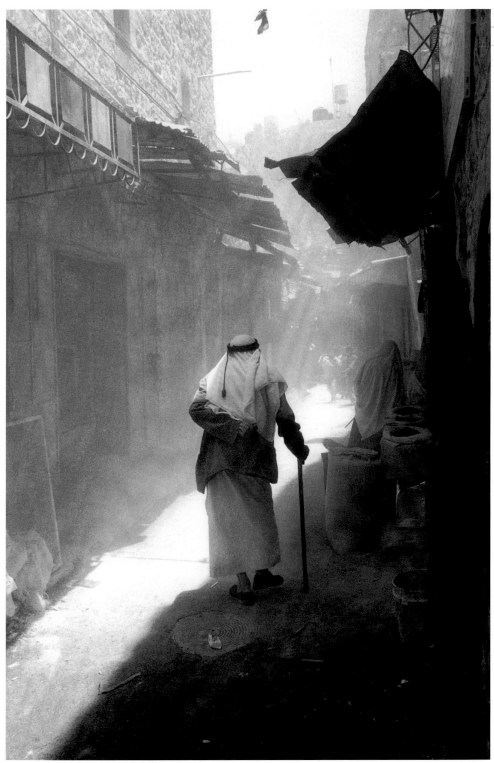

Hebron, 1998

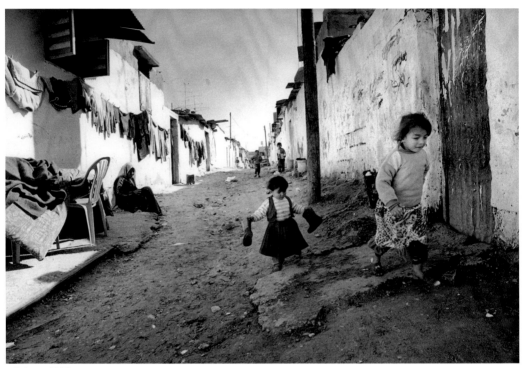

Zeitun, 1995

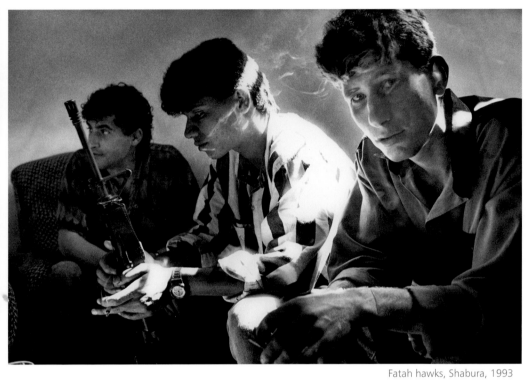

Fatah hawks, Shabura, 1993

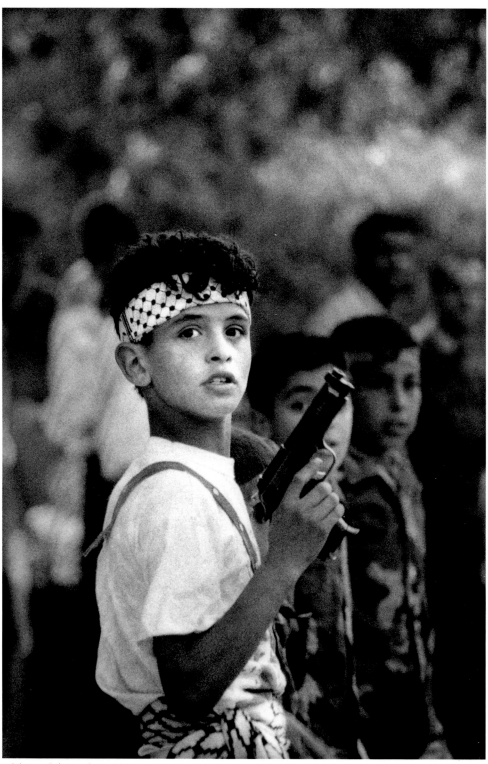

Prisoner Release, Gaza, 1994

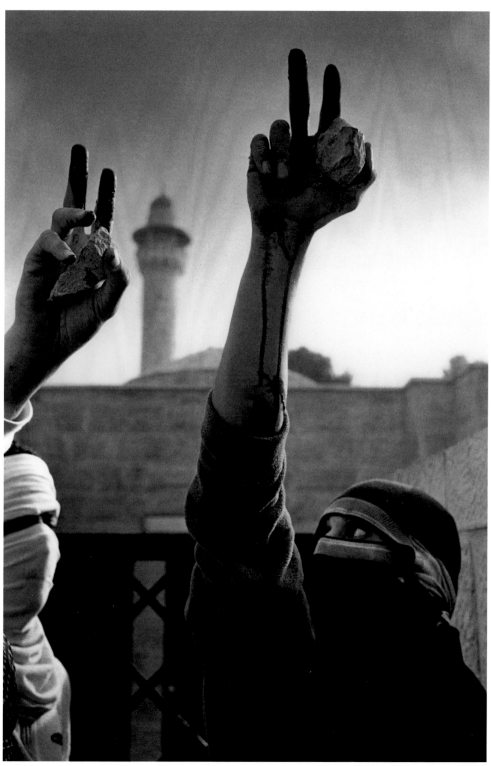

Lion's Gate, Jerusalem, 2000

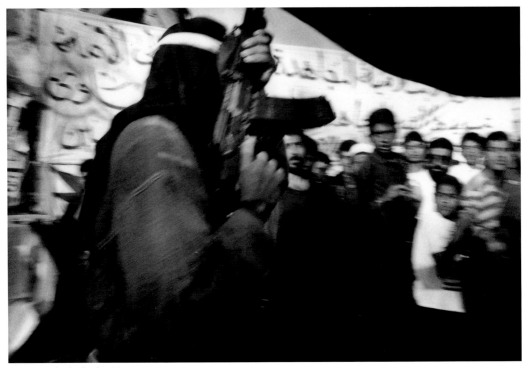

Islamic Jihad, Shati, 1994

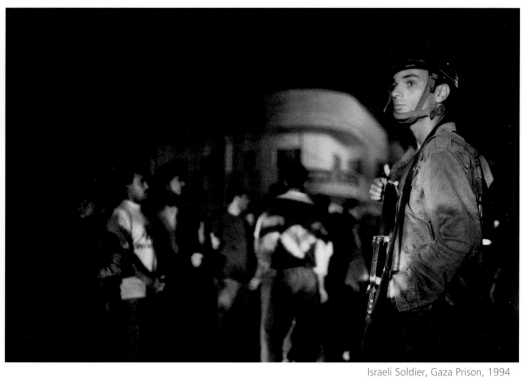

Israeli Soldier, Gaza Prison, 1994

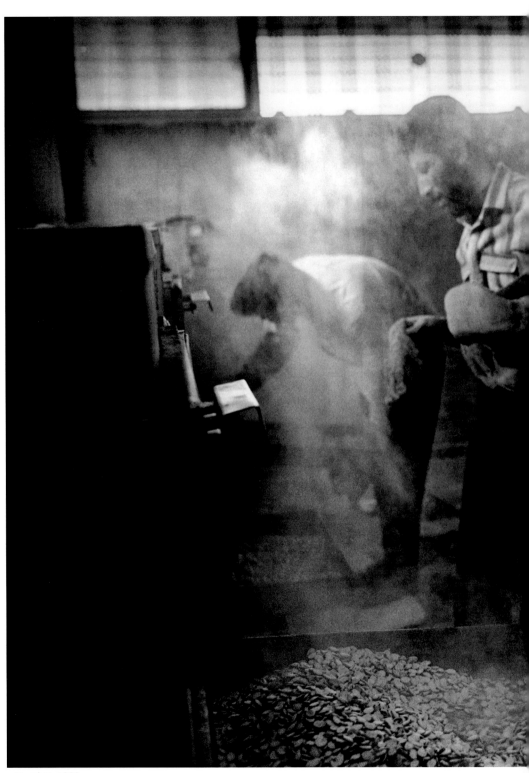

Nuseirat, 1992

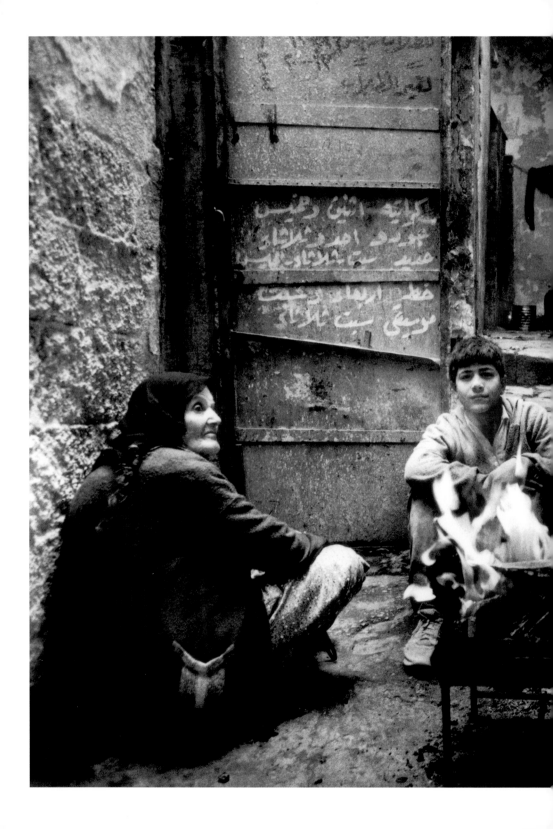

Winter, Jersualem, 1992

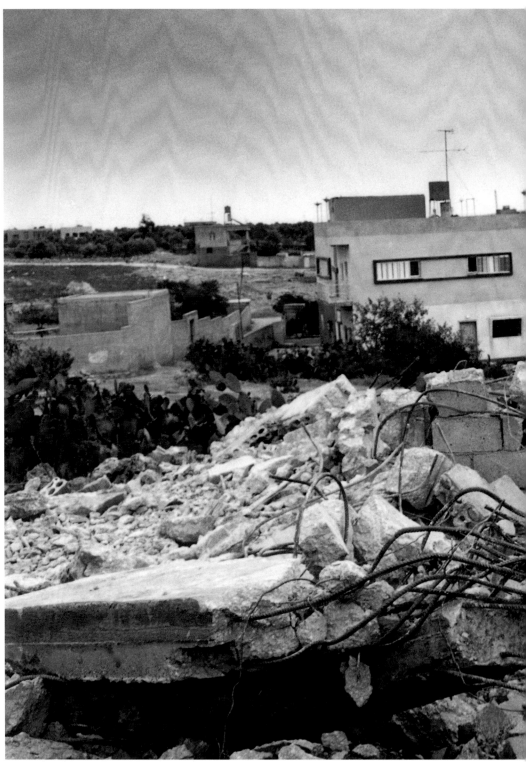

Demolished house, Zawata, 1993

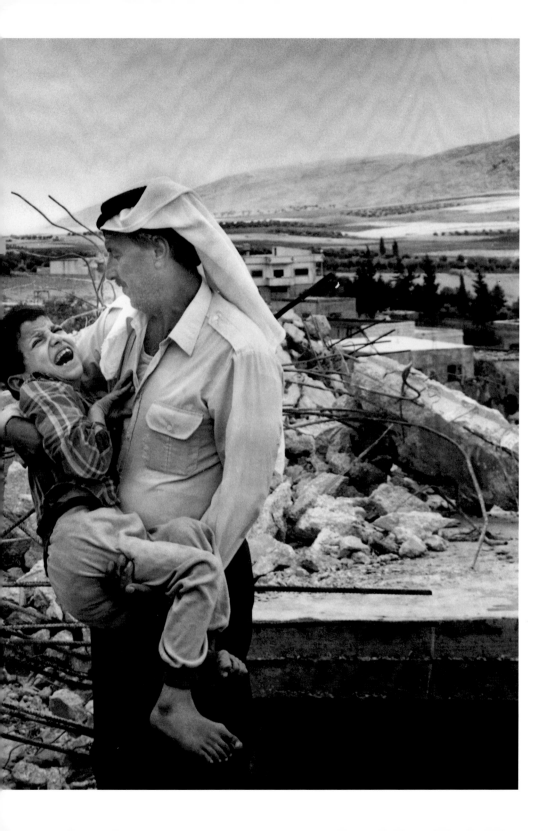

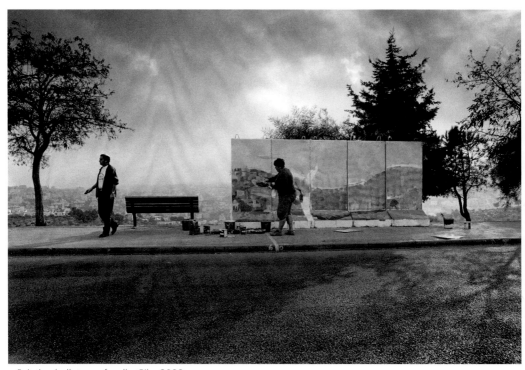

Painting bullet-proof walls, Gilo, 2000

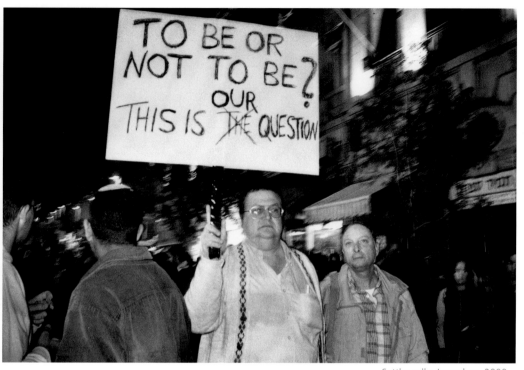

Settler rally, Jerusalem, 2000

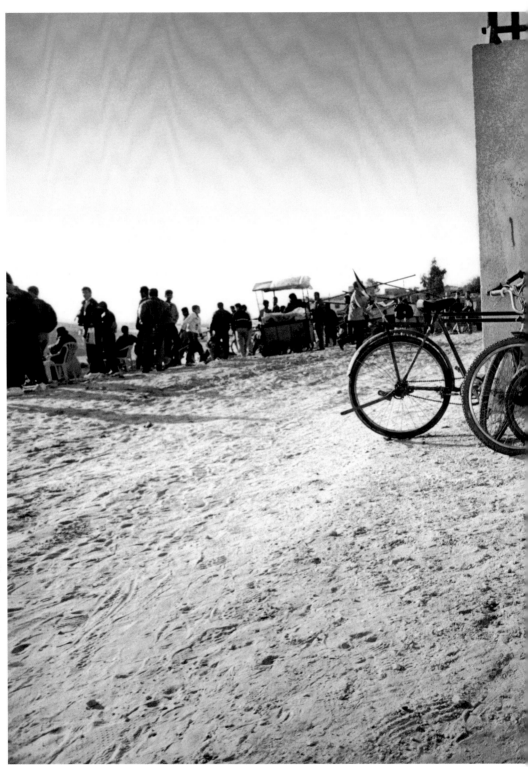

Khan Yunis, 1993

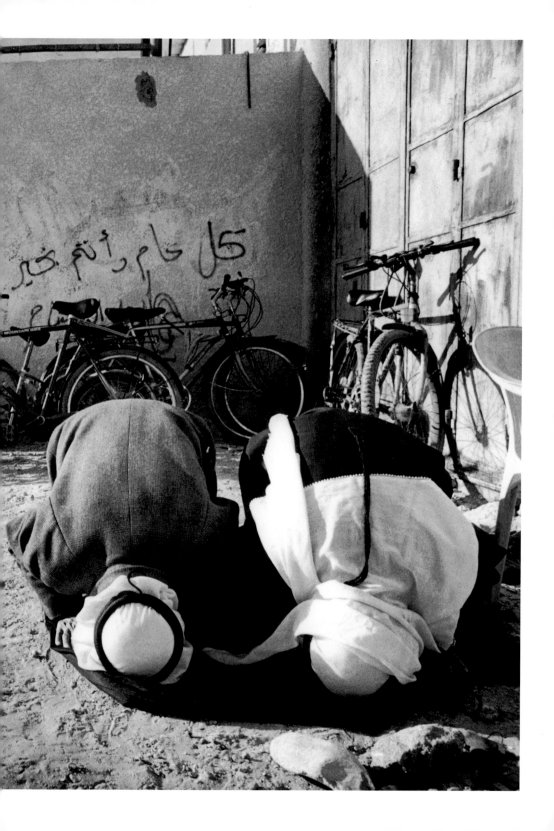

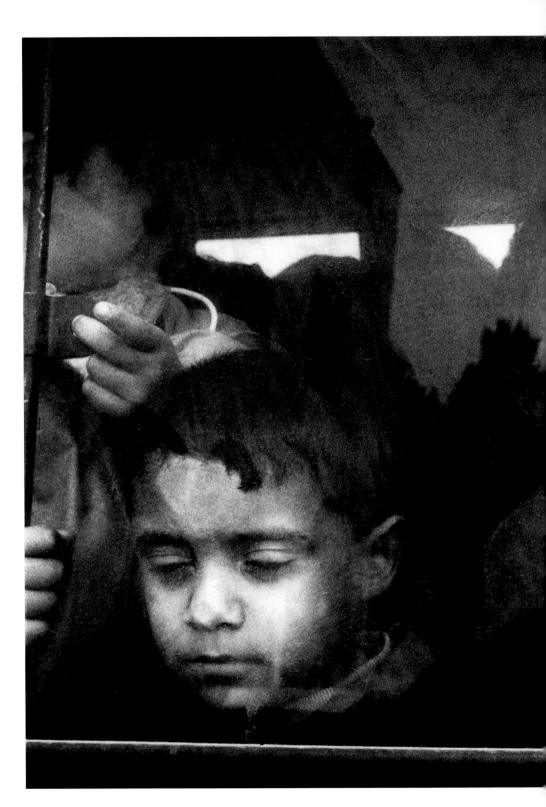

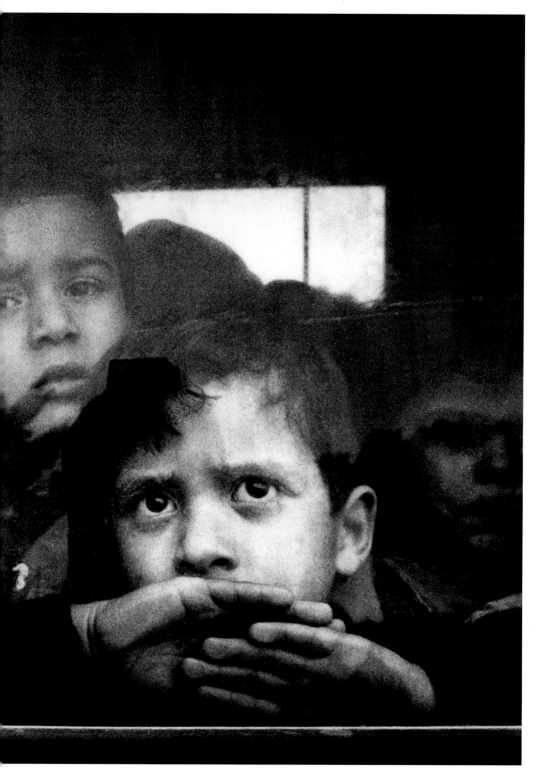

Nuseirat, 1992

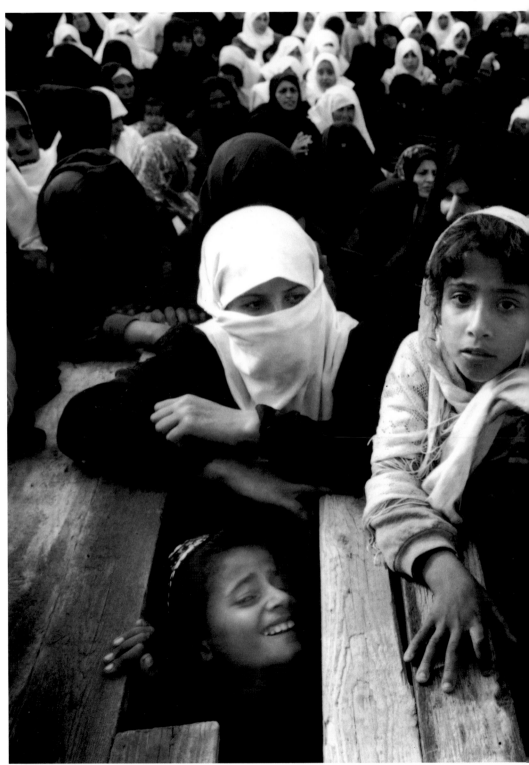

Khan Yunis, 1994

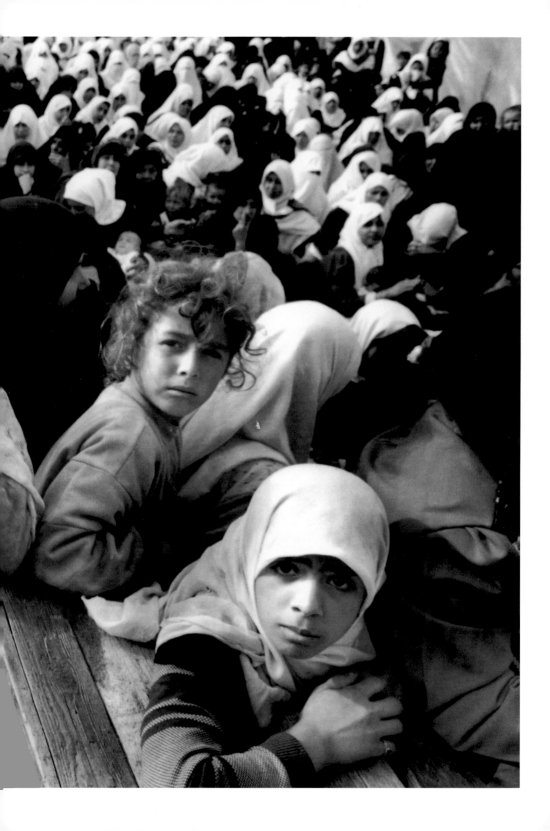

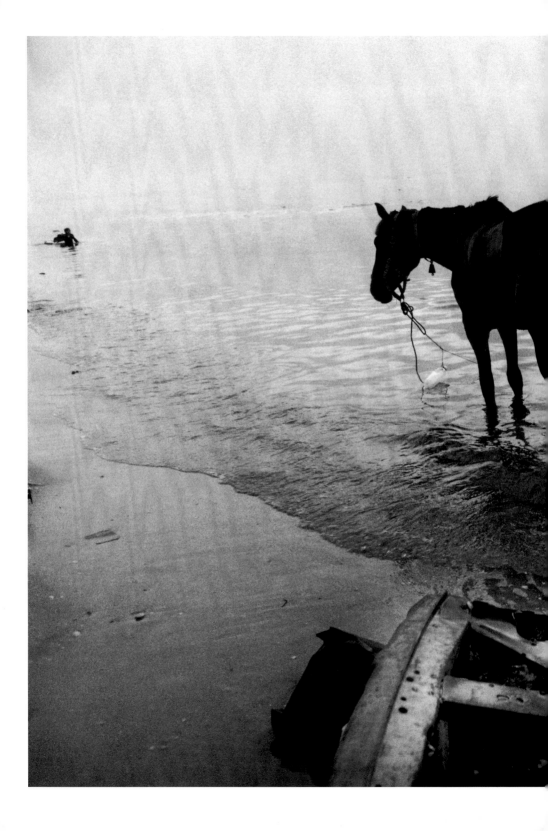

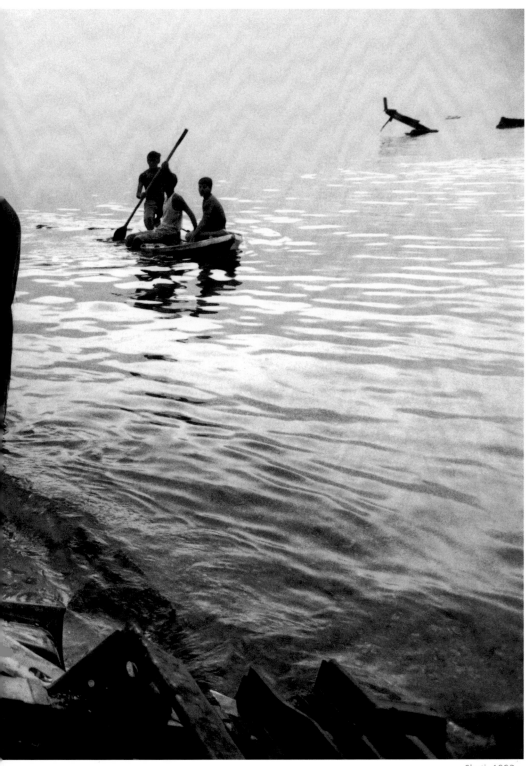

Shati, 1993

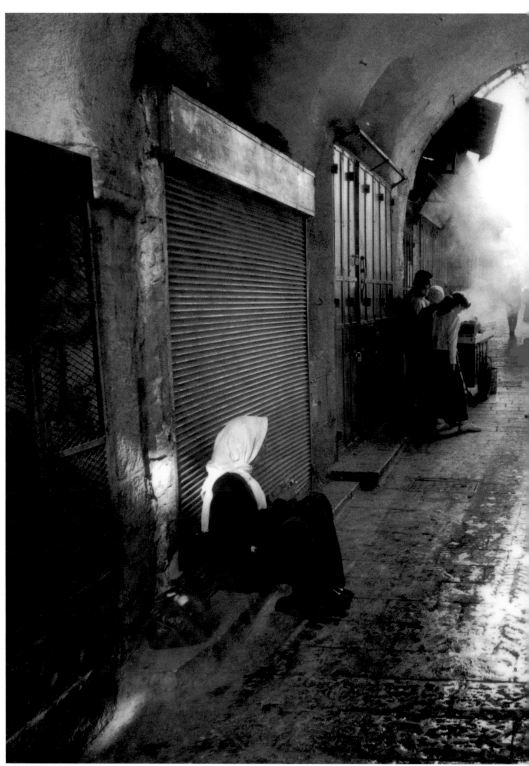

Jerusalem, 1991

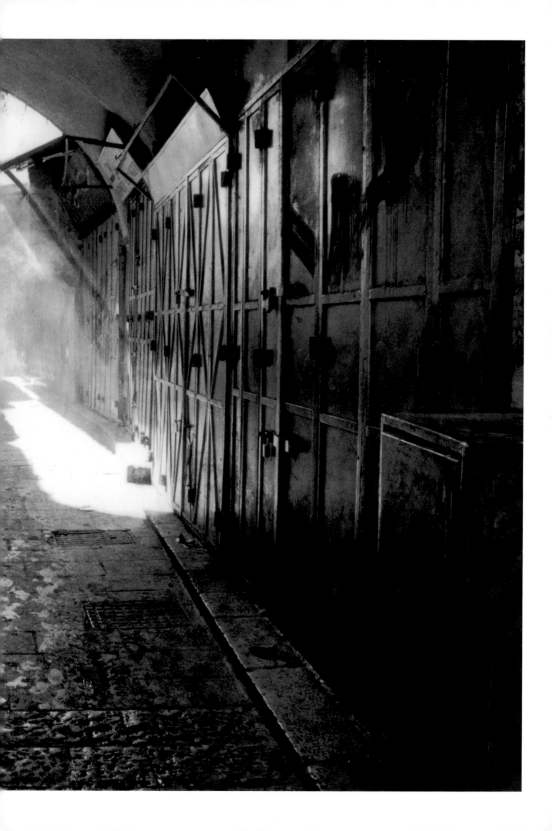

Eidal Fitr, Rafah, 1993

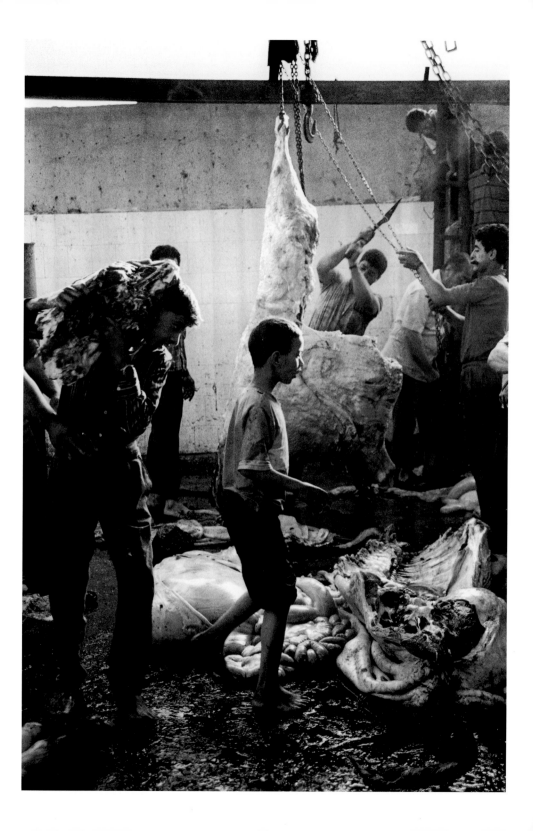

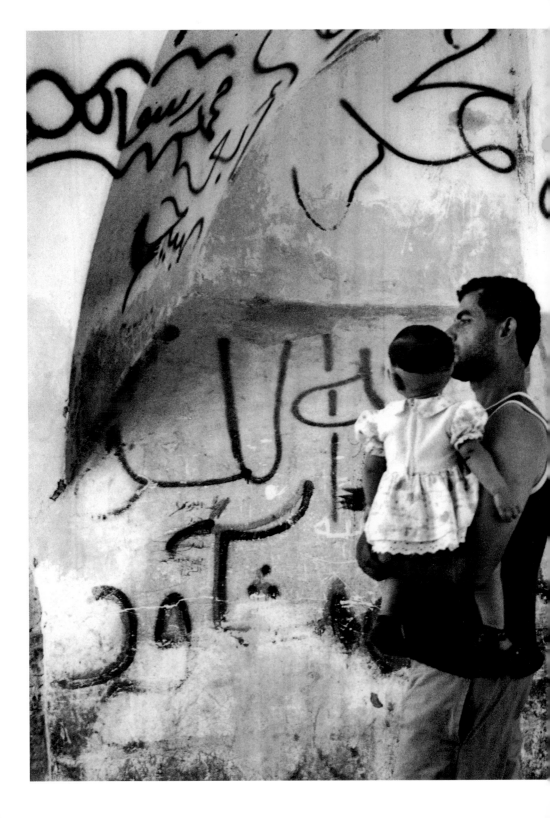

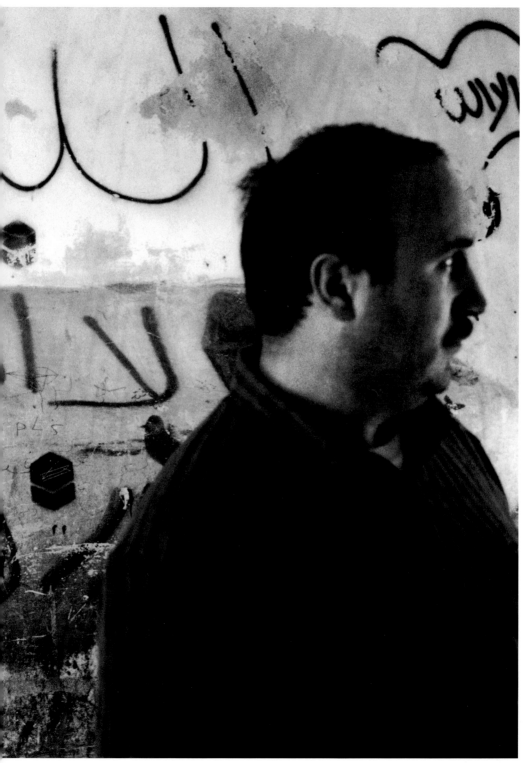

Jerusalem, 1998

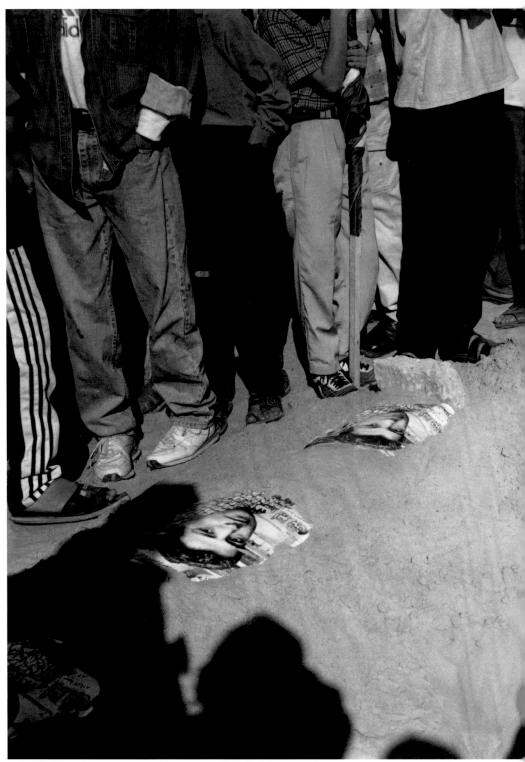

Martyrs' Cemetery, Gaza, 2000

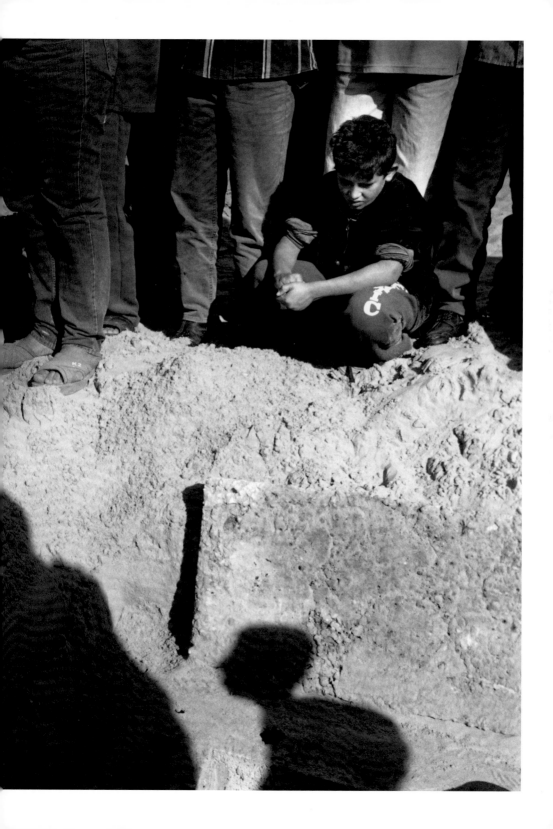

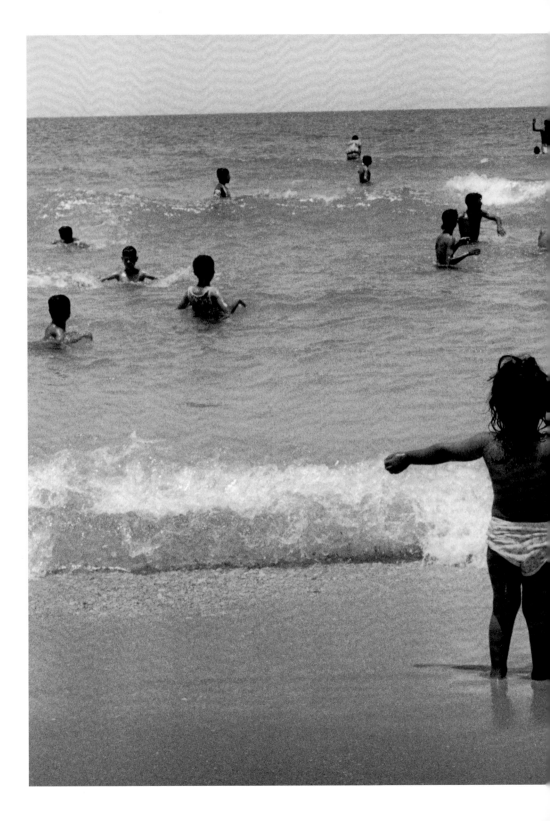

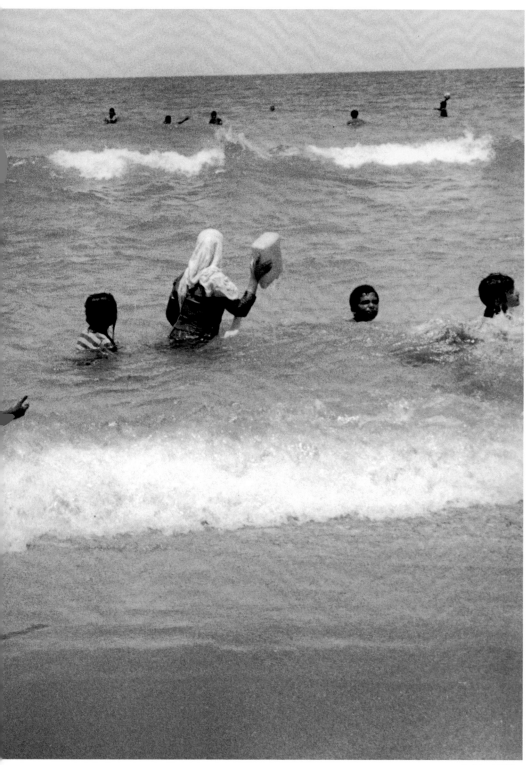

Rafah, 1993

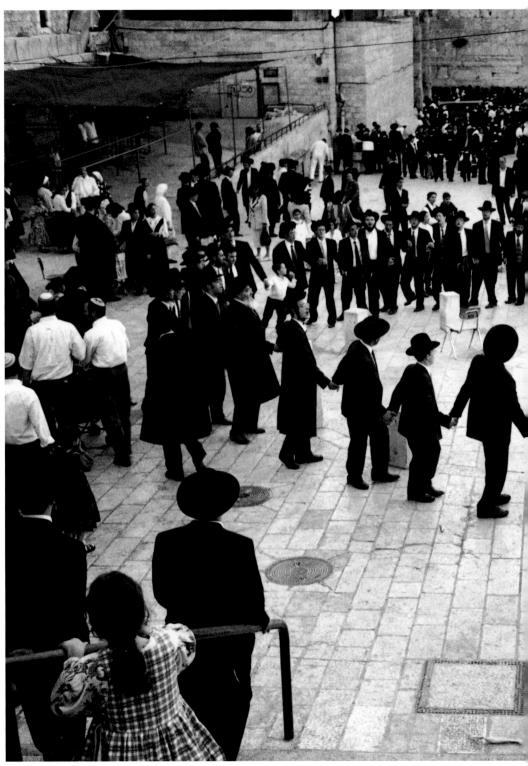

Western Wall, Jerusalem, 1998

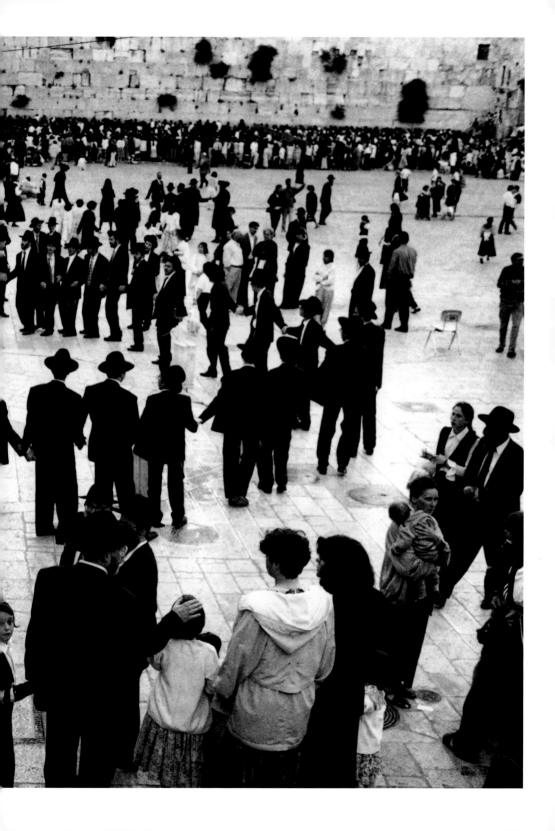

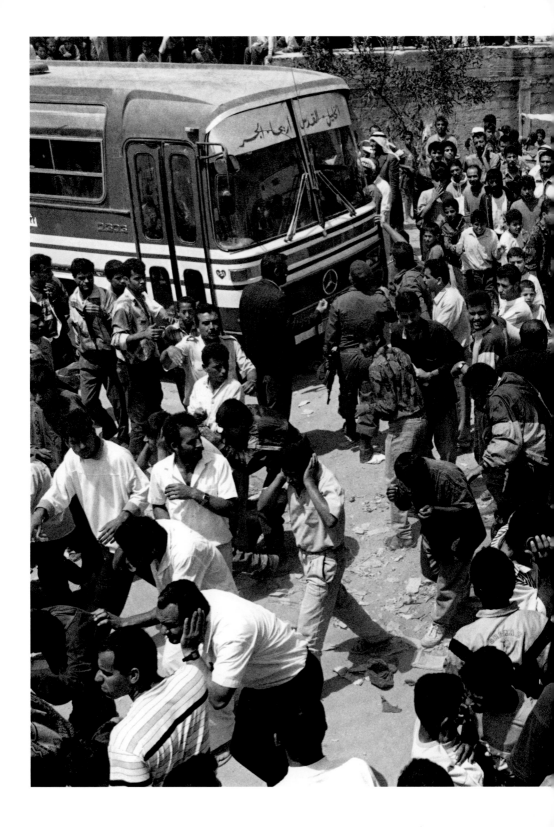

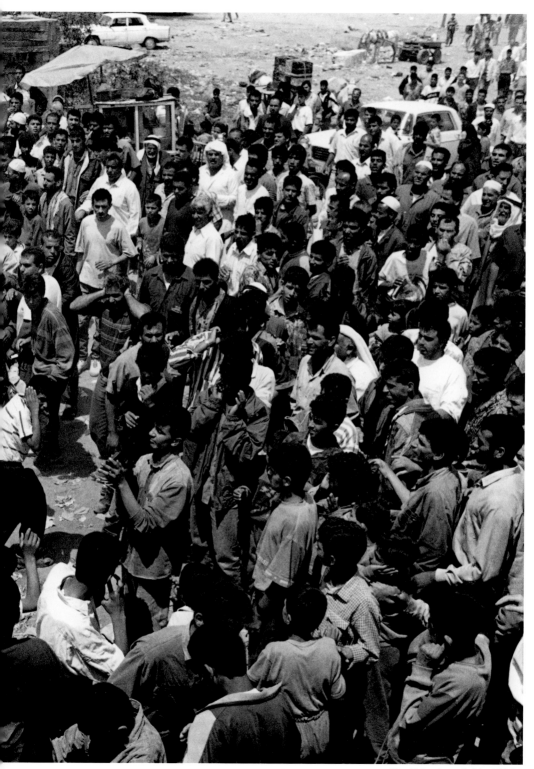

The PLA return, Rafah, 1994

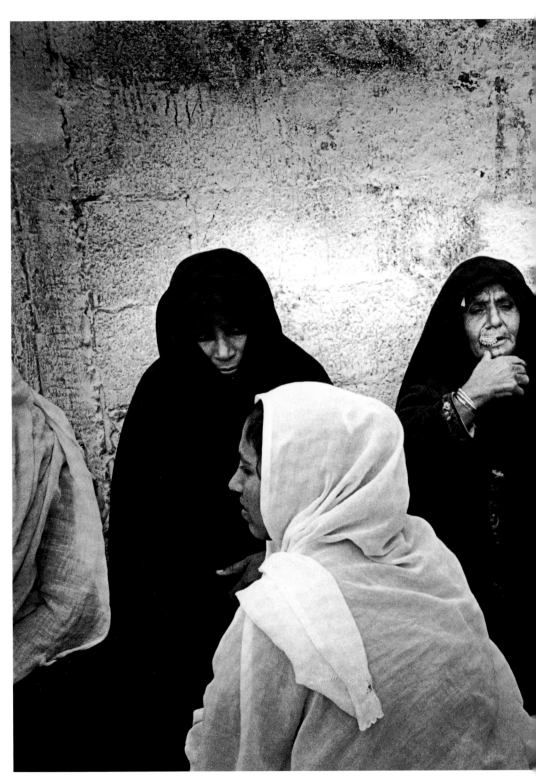

Nuseirat, 1992

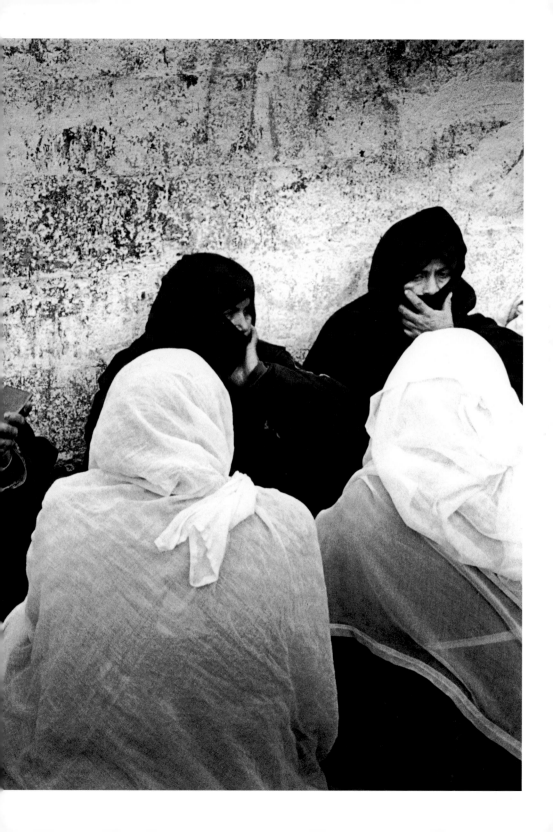

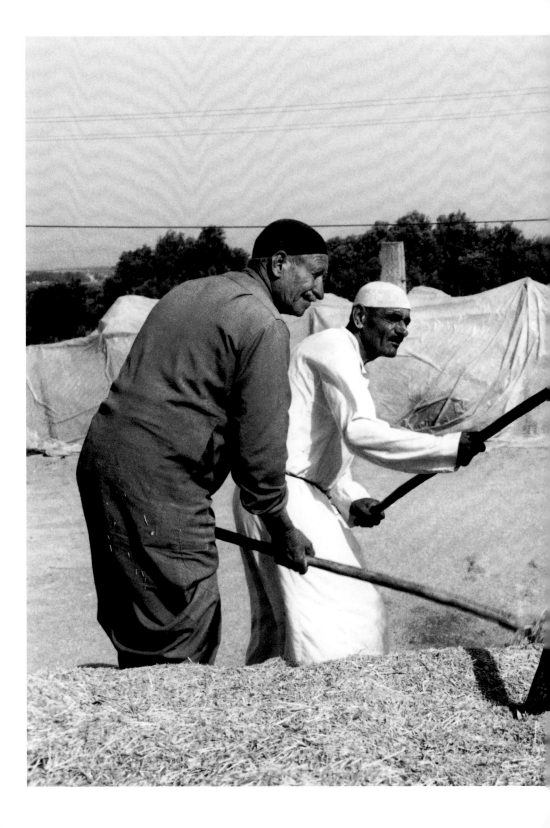

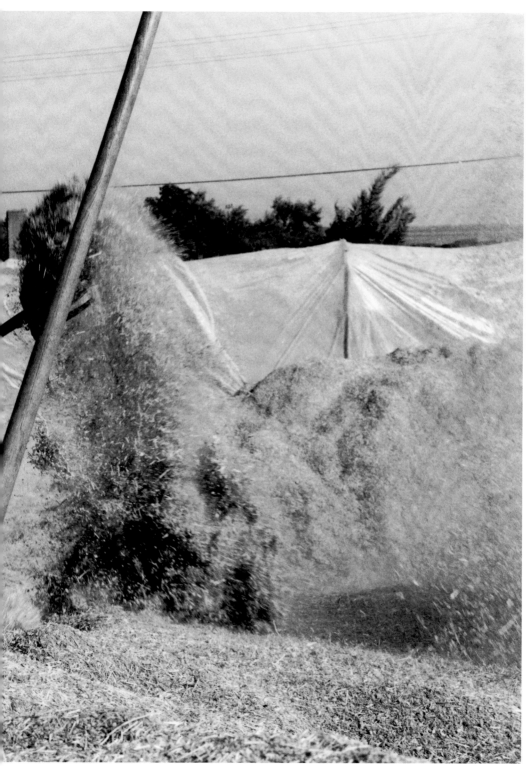

Gaza, 1994

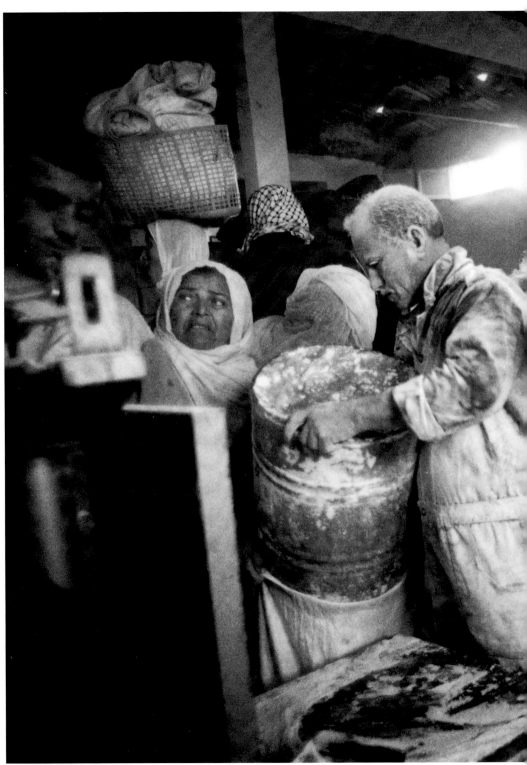

UNRWA, Jabalya, 1991

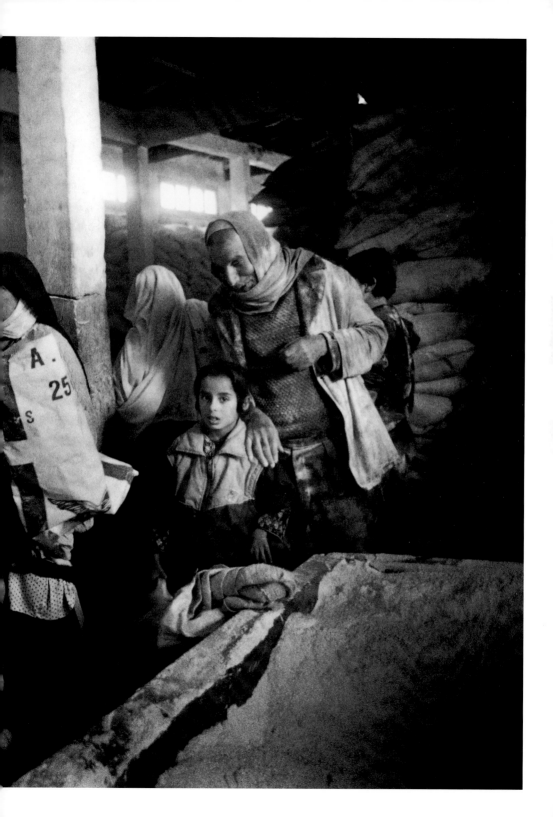

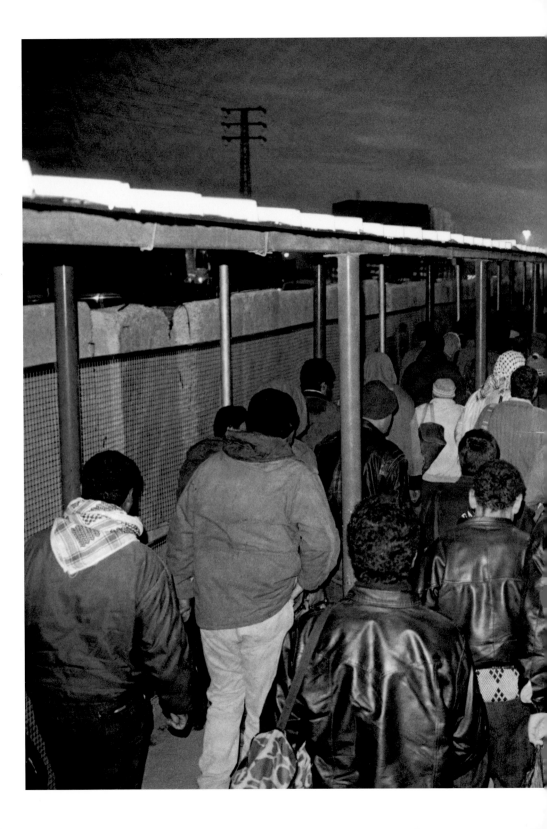

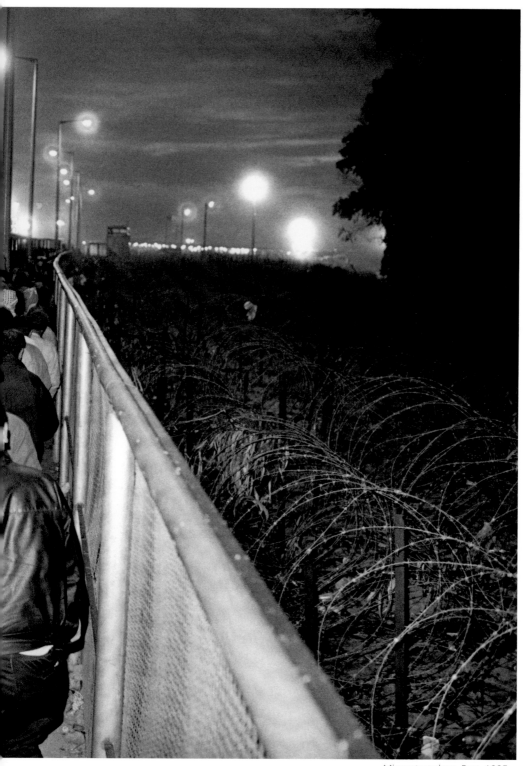

Migrant workers, Erez, 1995

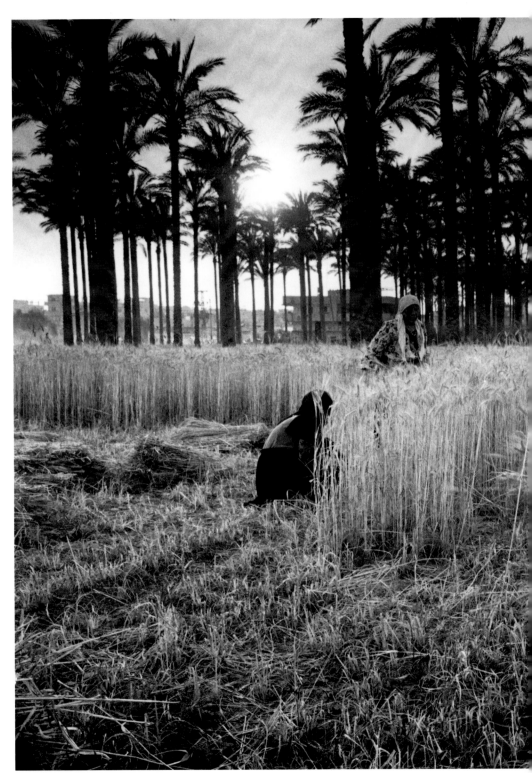

Deir el Balah, 1993

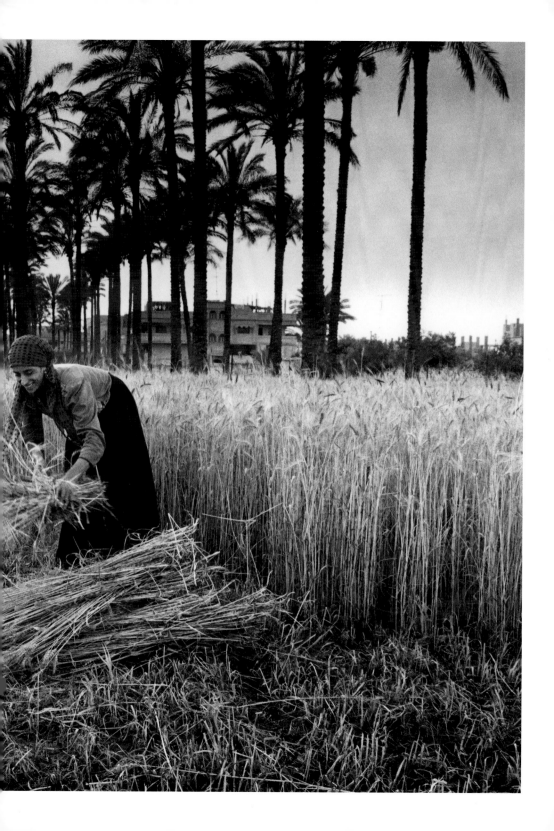

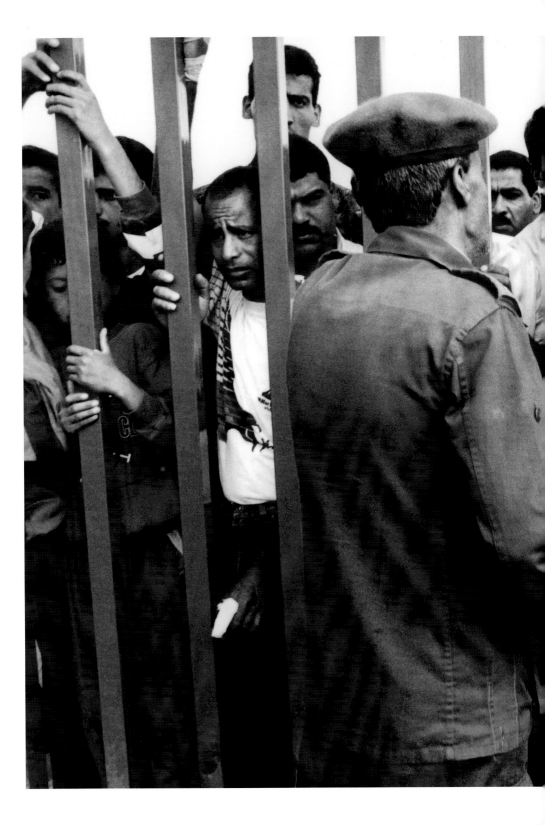

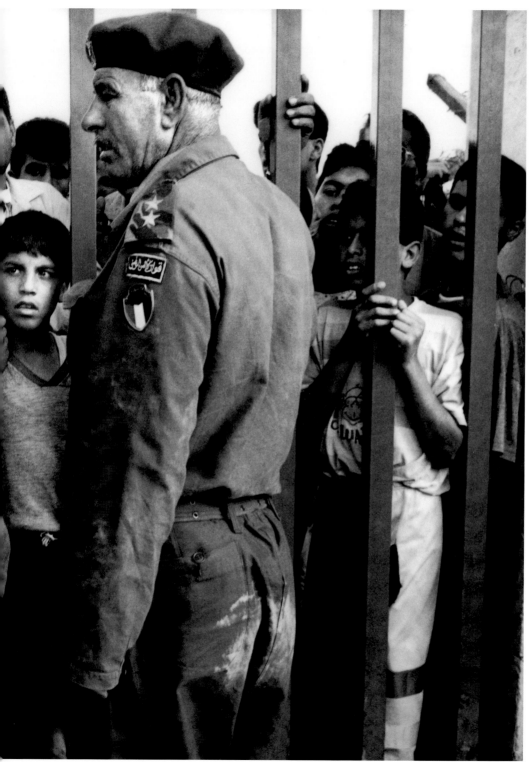

Bureij, 1994

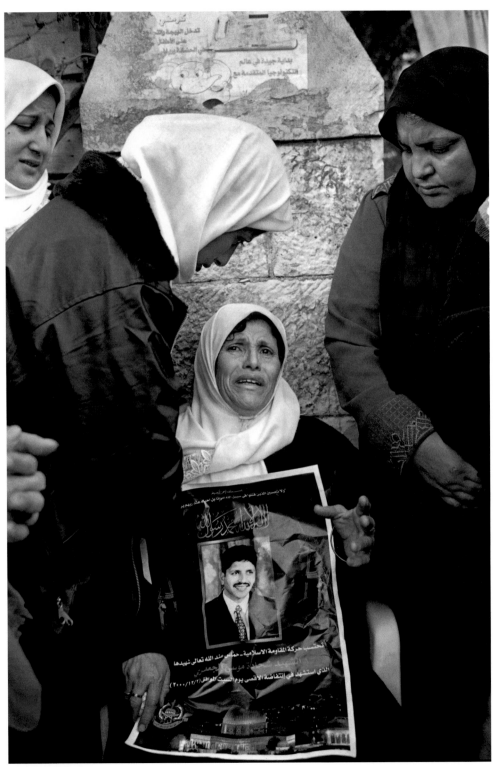

Ramallah, 2000

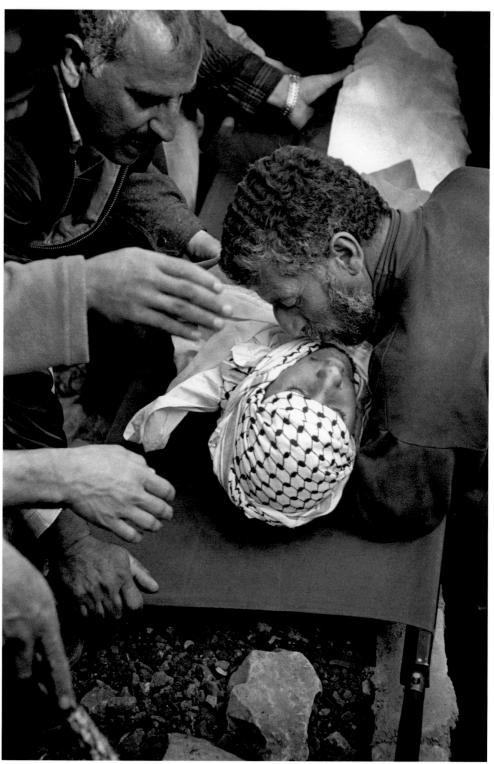

Artas, 2000

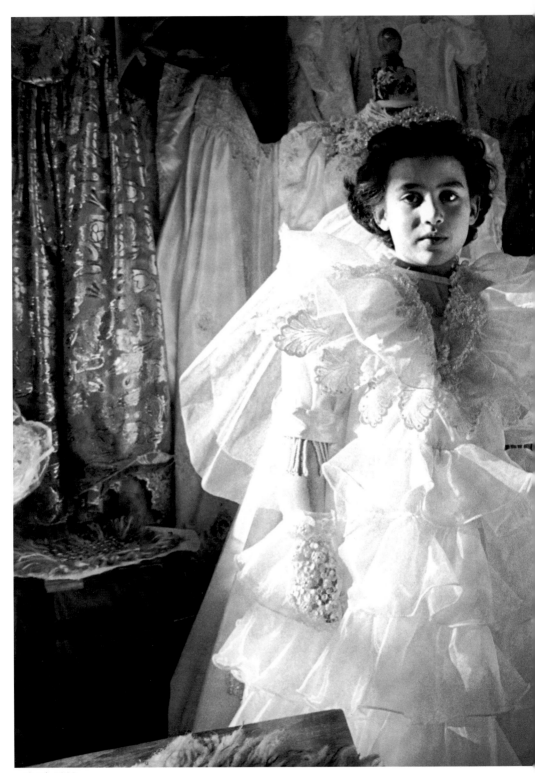

Rimal, 1993

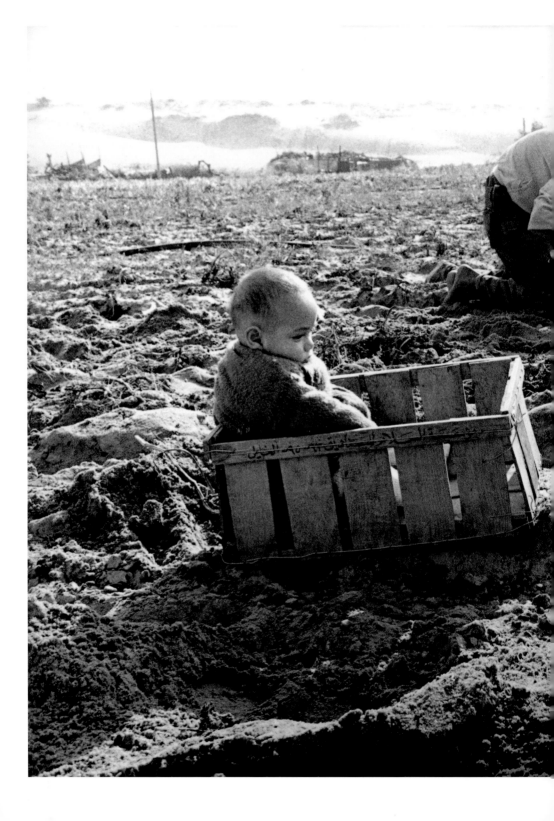

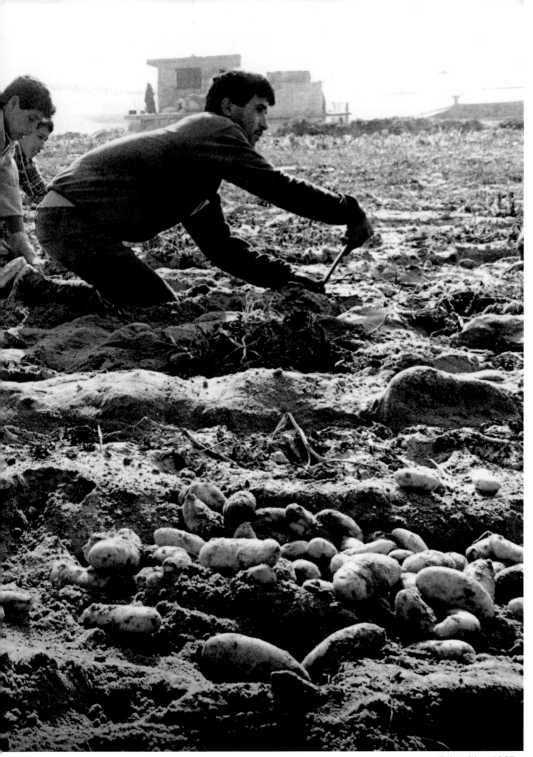

Beit Lahiya, 1995

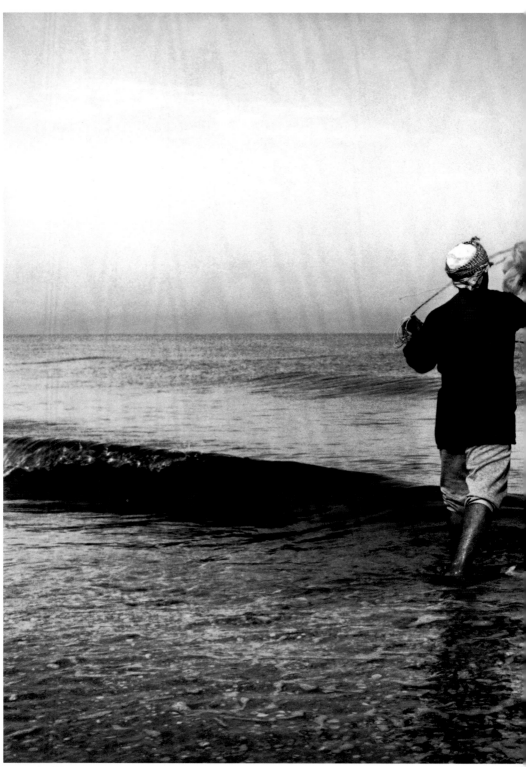

Deir el Balah, 1993

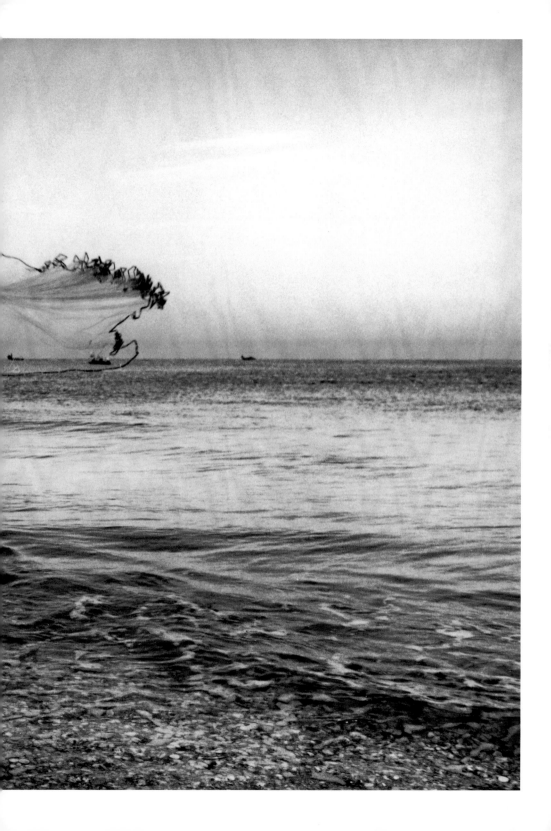

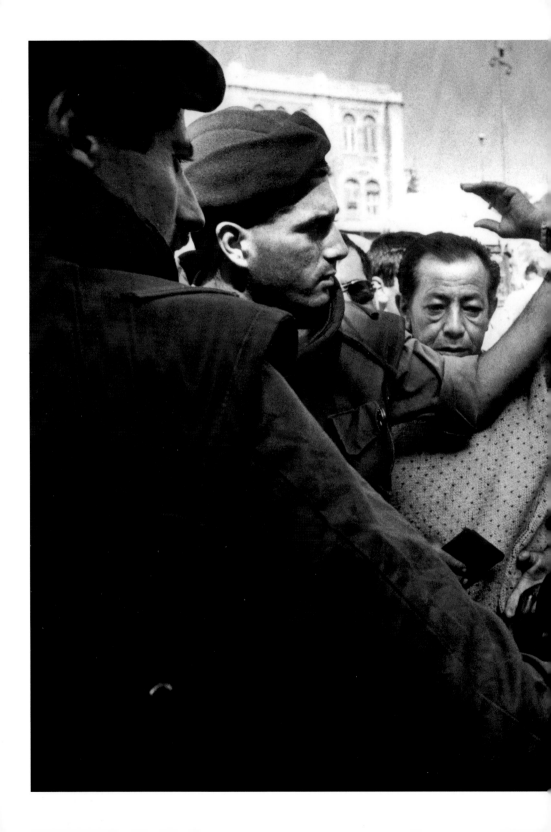

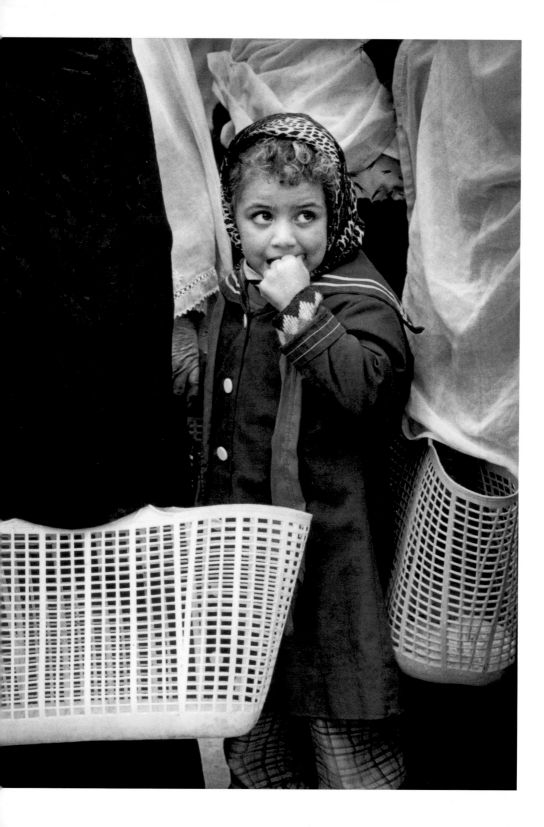

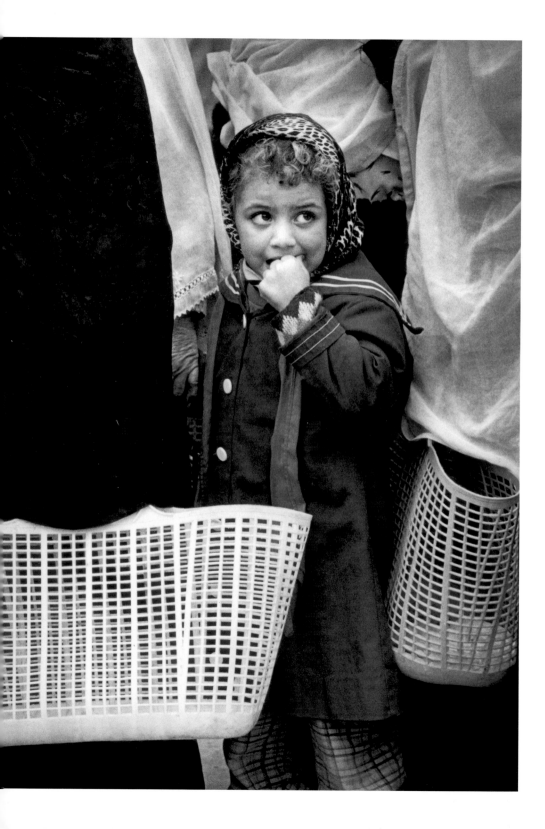

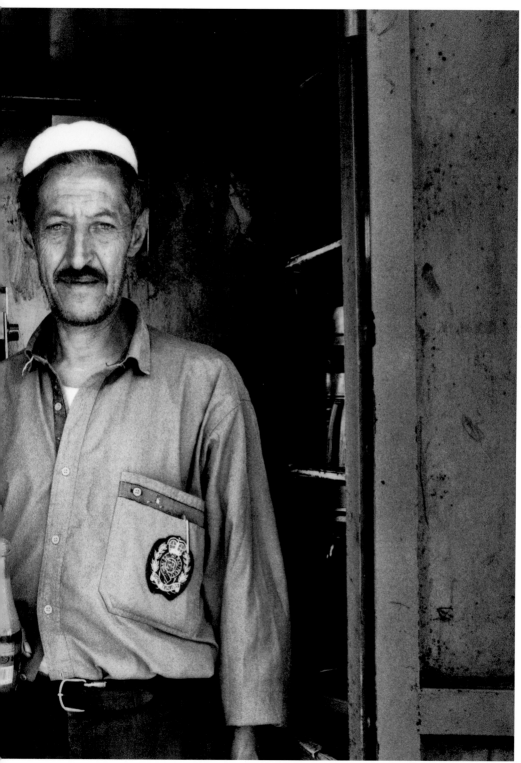

Hebron, 1998

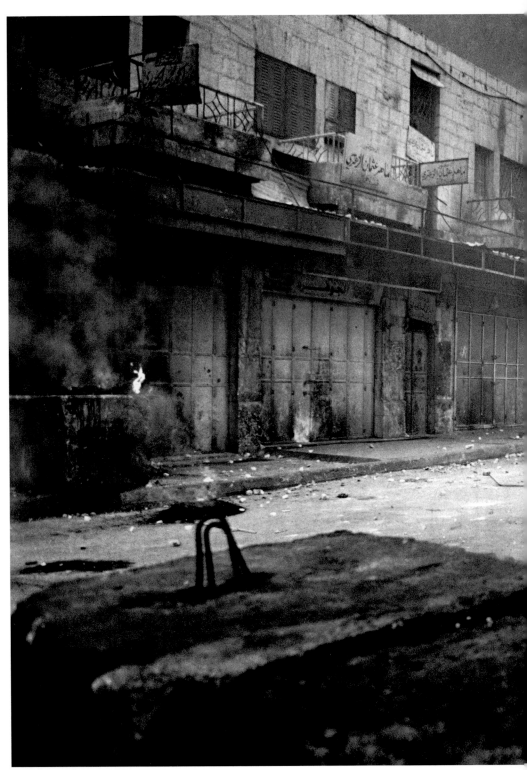

Hebron, 2000

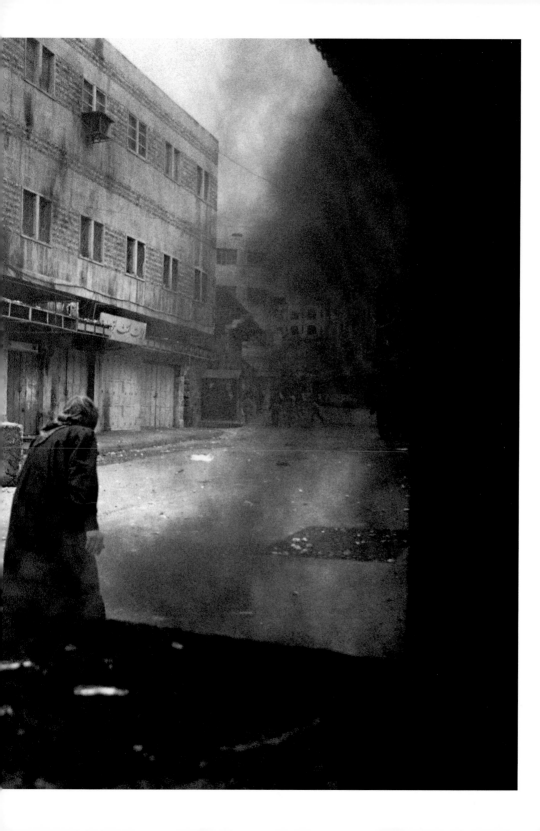

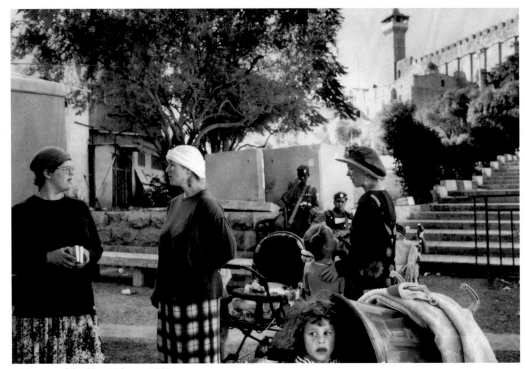

Mosque of Ibrahim, Hebron, 1998

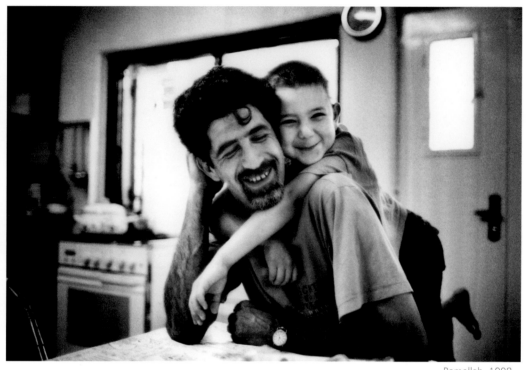

Ramallah, 1998

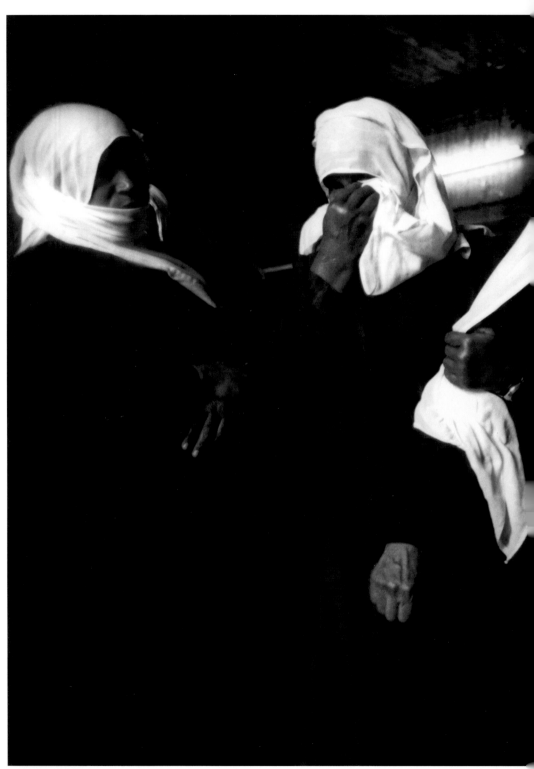

Gaza City, 1994

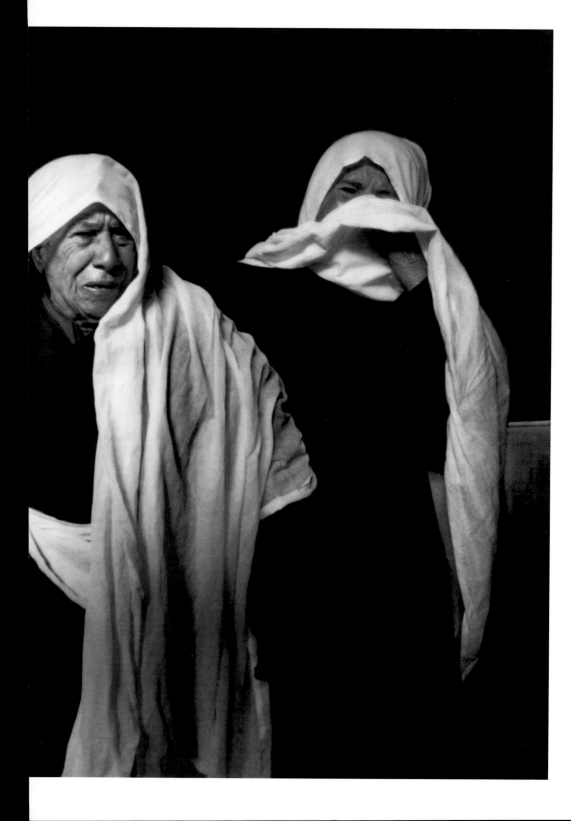

Israel, 1998

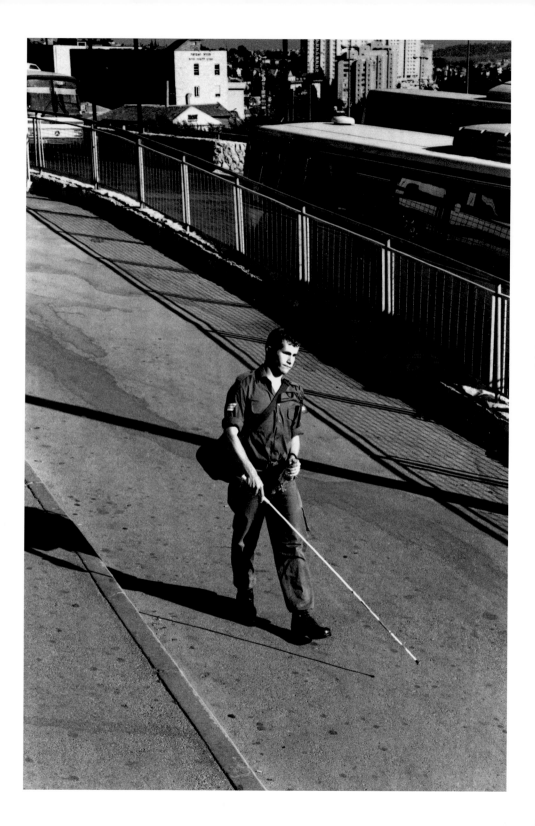

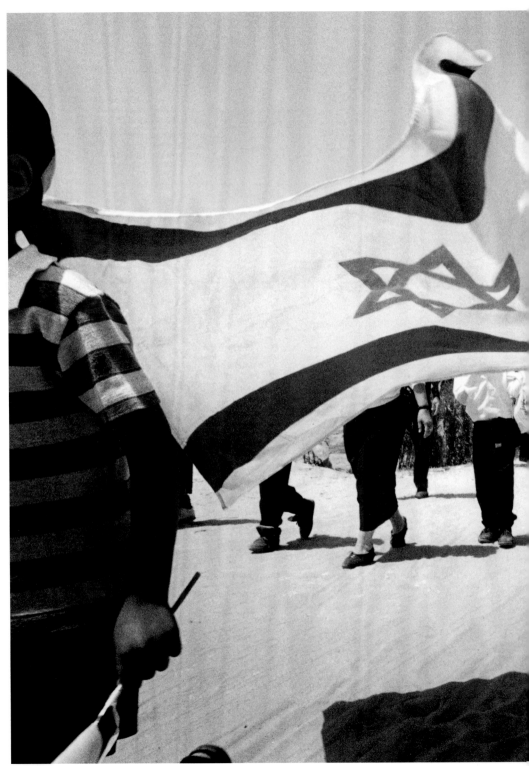

Independence Day, Newe Dequalim, 1994

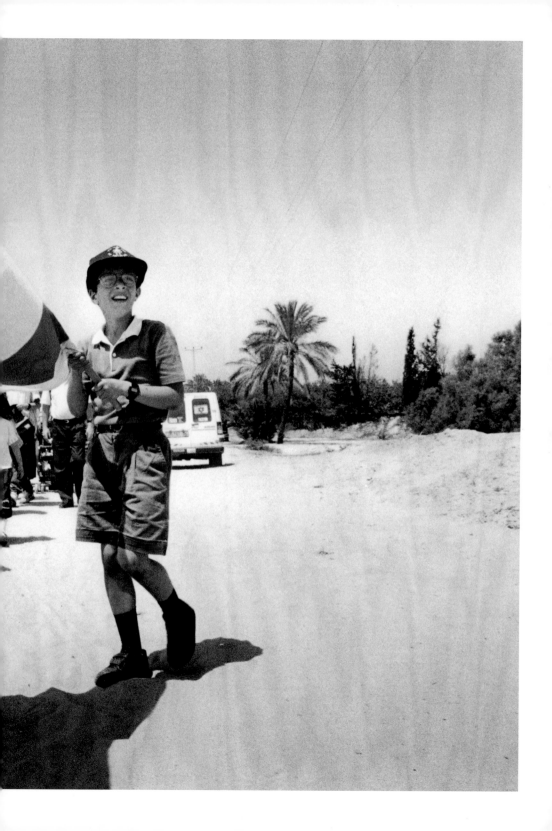

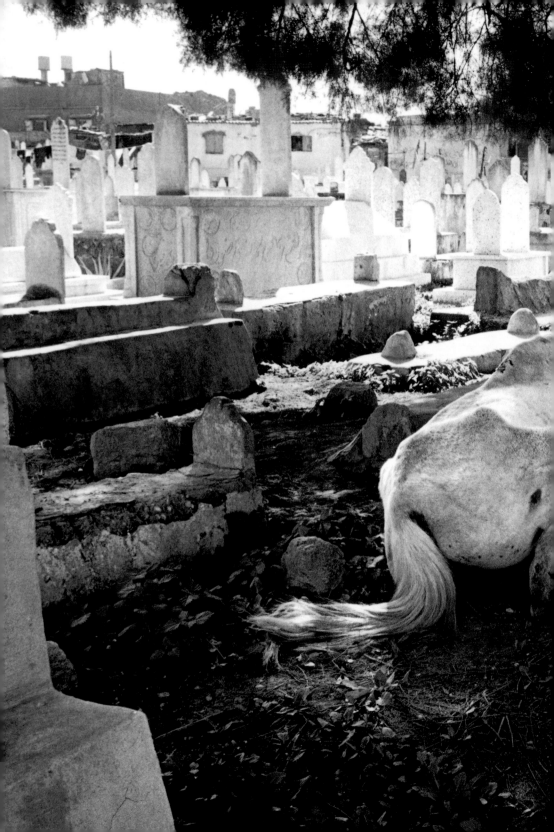

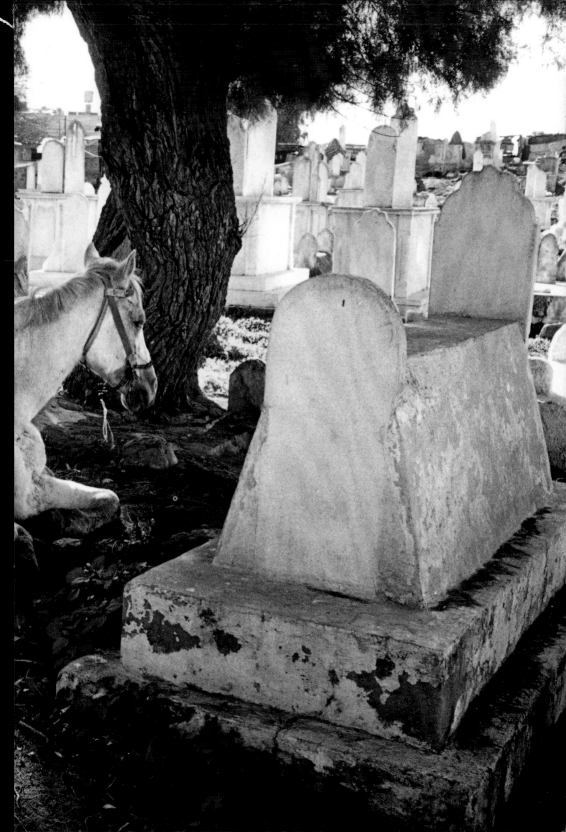

Previous page: Palestine, 1993

The authors would like to thank the many who contributed to this work

With thanks to the Jerusalem Fund

First published in the UK in 2001 by
Dewi Lewis Publishing
8 Broomfield Road
Heaton Moor
Stockport SK4 4ND
+44 (0)161 442 9450
www.dewilewispublishing.com

ISBN: 1-899235-53-1

Design & Artwork production: Dewi Lewis Publishing
Duotone separations and print: EBS, Verona, Italy